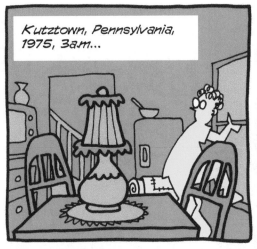

Kutztown, Pennsylvania, 1975, 3am...

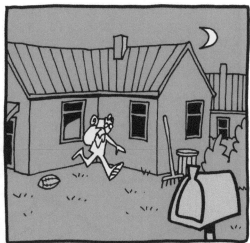

NOBODY NOTICED ANYTHING. NOT MY PARENTS, NOT MY SISTERS NOR THE DOG.

Don't worry. I'm spending the summer with friends at the coast. See you soon. Keith.

NOW, NOW, NOW...

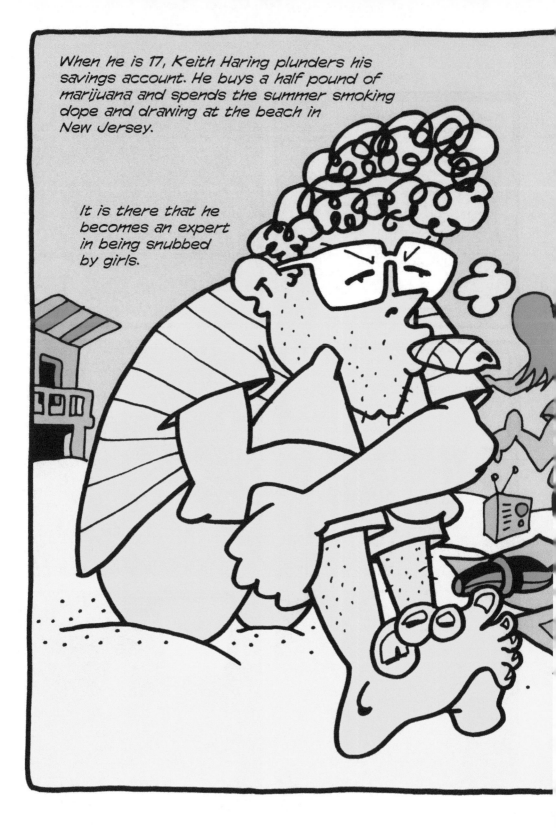

When he is 17, Keith Haring plunders his savings account. He buys a half pound of marijuana and spends the summer smoking dope and drawing at the beach in New Jersey.

It is there that he becomes an expert in being snubbed by girls.

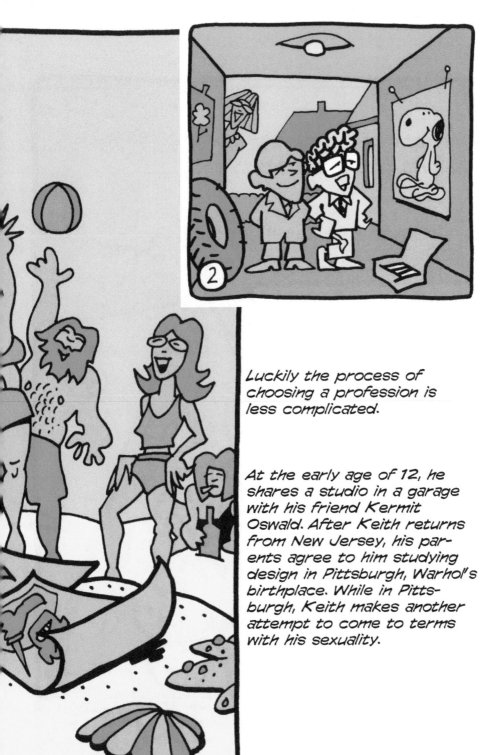

Luckily the process of choosing a profession is less complicated.

At the early age of 12, he shares a studio in a garage with his friend Kermit Oswald. After Keith returns from New Jersey, his parents agree to him studying design in Pittsburgh, Warhol's birthplace. While in Pittsburgh, Keith makes another attempt to come to terms with his sexuality.

To Suzy's regret, Keith discovers his true sexuality in the gay gathering points of the big cities.

Despite his first exhibition of abstract paintings in Pitts-burgh, it becomes clear to him that his future lies in New York.

On a Friday in 1978, Allen Haring drops his son off in New York at the YMCA. In two days he will begin his studies at the School of Visual Arts.

Two days. That gives Keith Haring 48 hours to check out the West Village. He euphorically describes the area from Christopher Street to the piers of the Hudson River as a "Disneyland for gays."

On Monday he already has a place to live, sharing an apartment with some other men.

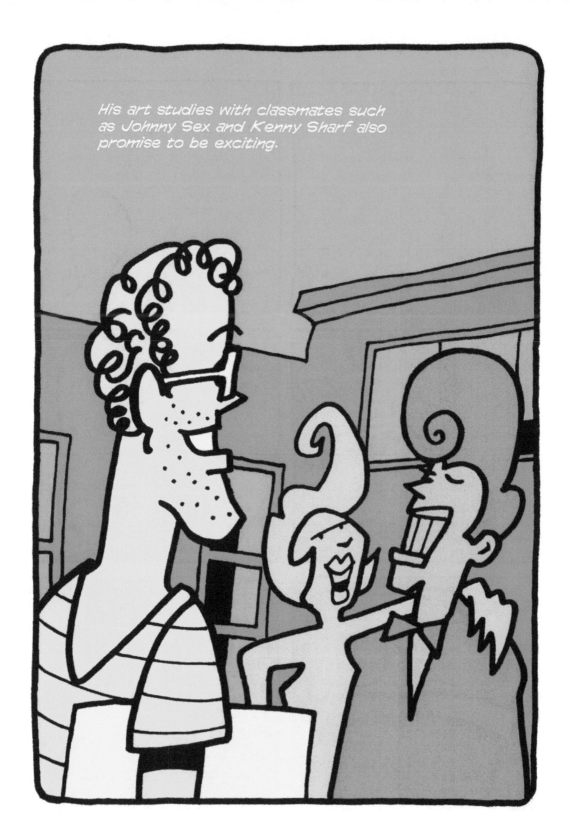

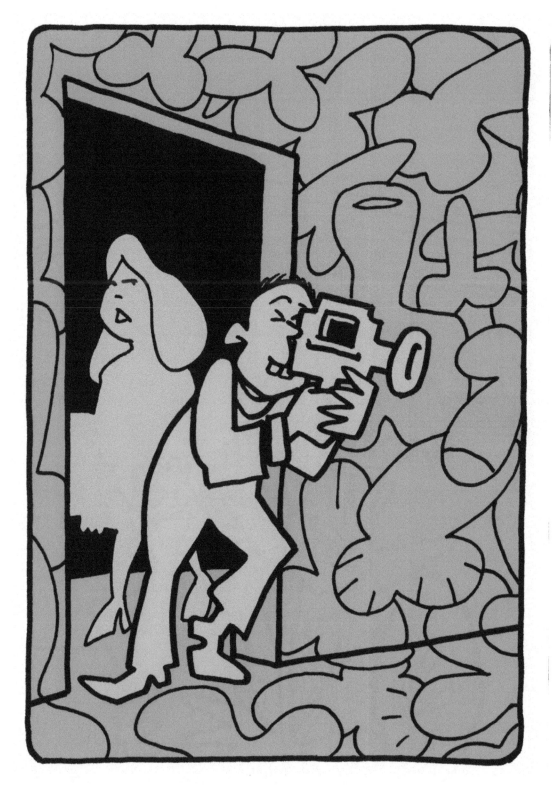

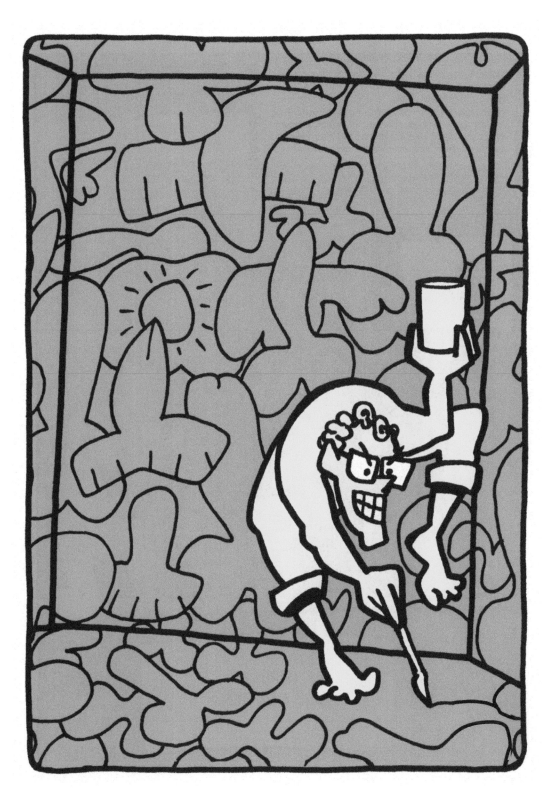

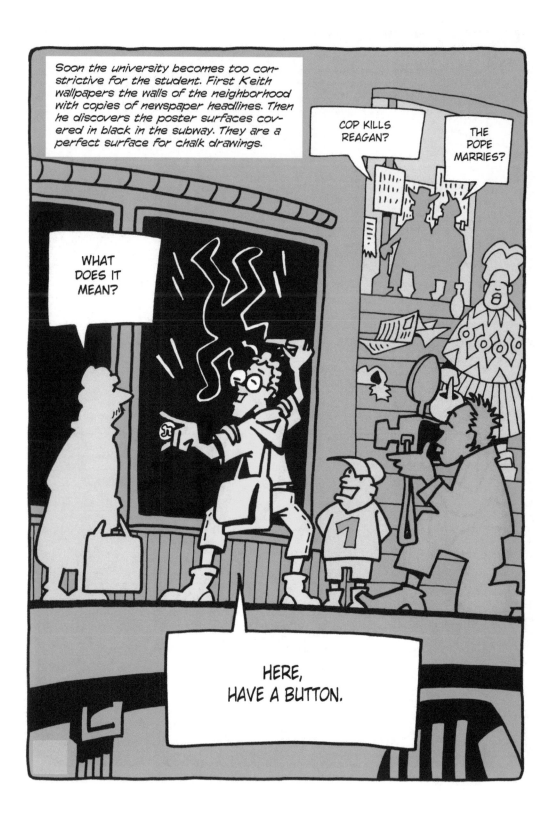

Kermit Oswald and Drew Straub had already worked in Kutztown in a similar style with carbon copies and chalk. But Keith Haring's intensity eclipses everything. He uses the subway for 4 years as his first gallery in order to increase his renown. There are days when he creates 40 pictures.

His classmate, Tseng Kwong Chi, takes photos of these activities from the start. He poses as a Japanese tourist when there are hassles with the law.

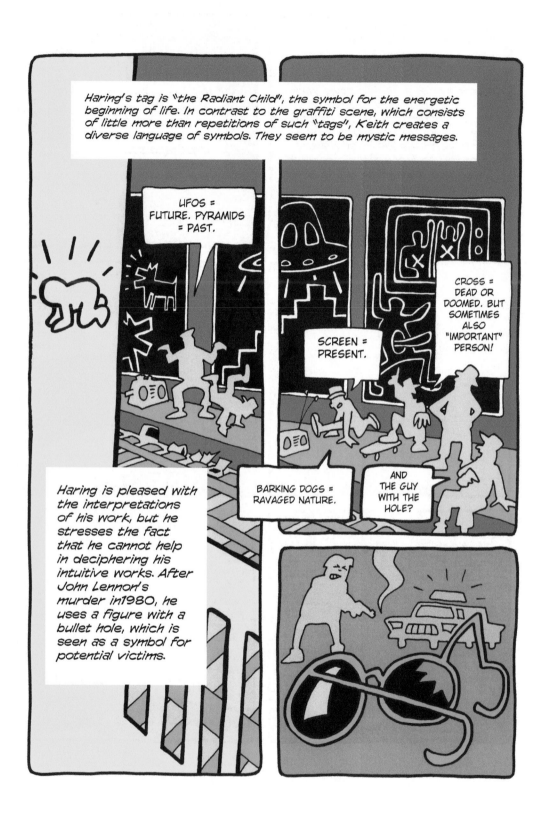

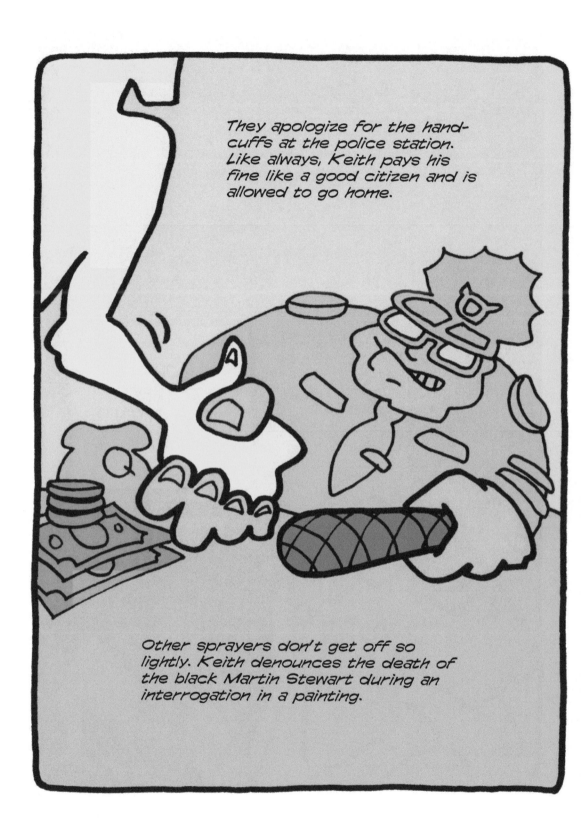

They apologize for the handcuffs at the police station. Like always, Keith pays his fine like a good citizen and is allowed to go home.

Other sprayers don't get off so lightly. Keith denounces the death of the black Martin Stewart during an interrogation in a painting.

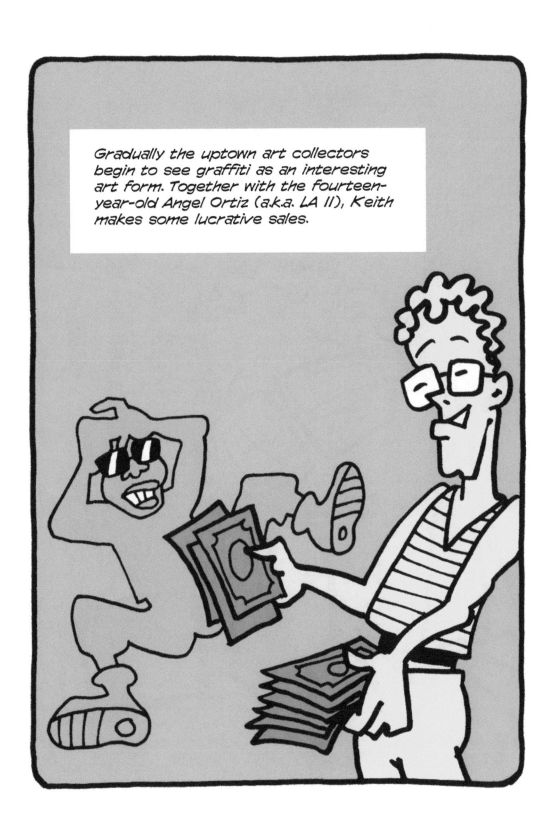

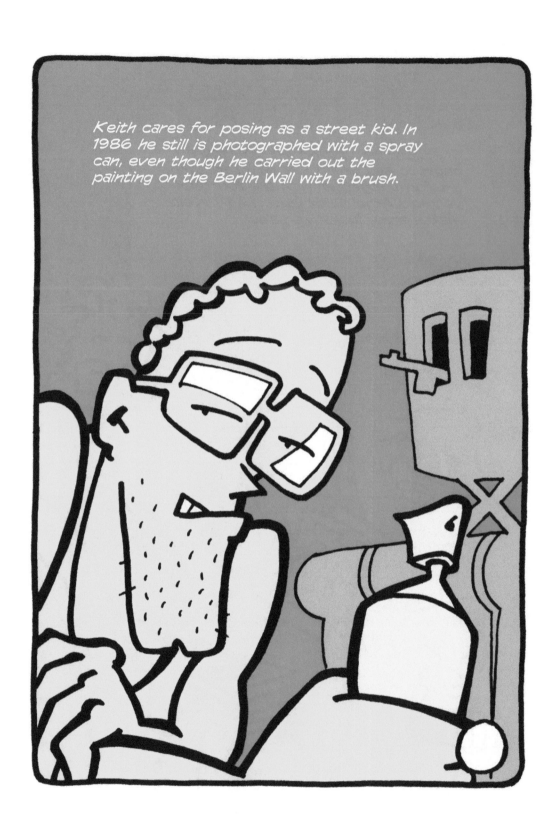

Keith cares for posing as a street kid. In 1986 he still is photographed with a spray can, even though he carried out the painting on the Berlin Wall with a brush.

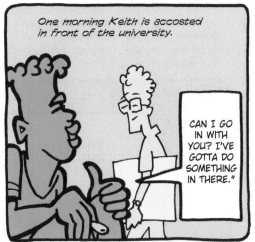

One morning Keith is accosted in front of the university.

"CAN I GO IN WITH YOU? I'VE GOTTA DO SOMETHING IN THERE."

One hour later.

WHAT DOES "SAMO" MEAN?

"SAME OLD SHIT!"

The tag "Samo" is used by Jean-Michel Basquiat, who, like Keith, is a young artist determined not to sell out to the art establishment.

MY ART DOESN'T BELONG IN MUSEUMS. THEY WOULDN'T EVEN LET MY FRIENDS IN.

Keith previously discovered the unpleasant difference between artists and the museum world when he worked as an assistant for gallery owner Toni Shafrazi.

THEY KEEP TALKING ABOUT MY "AFRICAN ROOTS." BUT I'M FROM BROOKLYN!

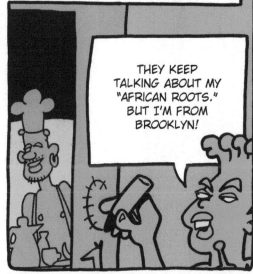

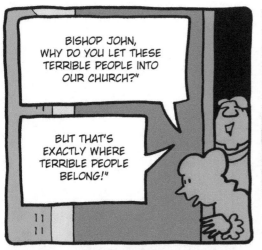

"BISHOP JOHN, WHY DO YOU LET THESE TERRIBLE PEOPLE INTO OUR CHURCH?"

"BUT THAT'S EXACTLY WHERE TERRIBLE PEOPLE BELONG!"

Keith proves to have a great talent for organizing art events in Club 57, a cellar that a Polish congregation allows the students to use. Soon he is involved in other spectacular underground happenings.

TODAY THE B-52'S

NOW, NOW, NOW ...

New York POST

Keith paints a picture with pink penises for the "Times Square Show" in a deserted house. Basquiat's contribution, a sign above the entrance is rejected as being "too misleading." Keith lets interested collectors, like the Rubells, wait for months.

FREE SEX

OKAY, I'LL BE IN TOUCH...

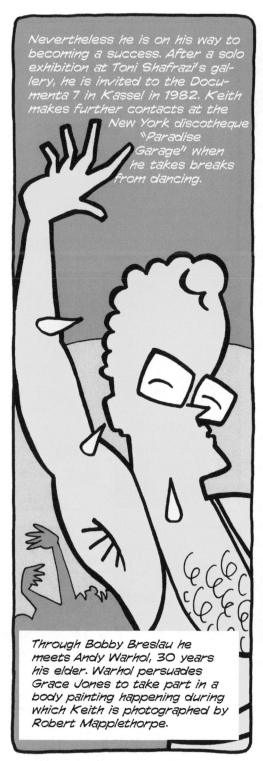

Nevertheless he is on his way to becoming a success. After a solo exhibition at Toni Shafrazi's gallery, he is invited to the Documenta 7 in Kassel in 1982. Keith makes further contacts at the New York discotheque "Paradise Garage" when he takes breaks from dancing.

Through Bobby Breslau he meets Andy Warhol, 30 years his elder. Warhol persuades Grace Jones to take part in a body painting happening during which Keith is photographed by Robert Mapplethorpe.

Madonna, at that time an unknown singer, becomes a close friend. Even though they overlap occasionally in their choice of partners, it has no effect on their friendship.

The Cultural Affairs Commissioner Henry Geldzahler, an old friend and supporter of Andy Warhol's, does his best to reconcile his enthusiasm for Keith Haring with the anti-graffiti campaign of his employer, Ed Koch, the mayor of New York.

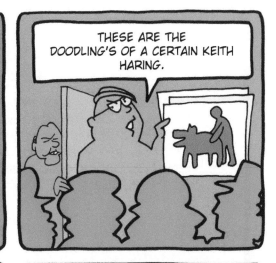

THESE ARE THE DOODLING'S OF A CERTAIN KEITH HARING.

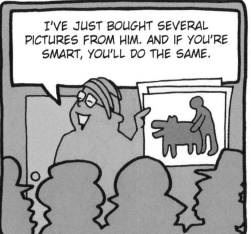

I'VE JUST BOUGHT SEVERAL PICTURES FROM HIM. AND IF YOU'RE SMART, YOU'LL DO THE SAME.

Keith meets Mayor Koch in 1984 on the occasion of a garbage prevention action, to which he contributes a cartoon. The invitations from abroad are much more cordial and from 1984 Keith concentrates on taking advantage of them.

In Melbourne, Australia, he paints a giant glass wall in his two-dimensional style. Although he affirms that he knows nothing about Aboriginal art, there is a wave of protest about an American borrowing Australian traditions. Two months later the glass wall is destroyed by a shot.

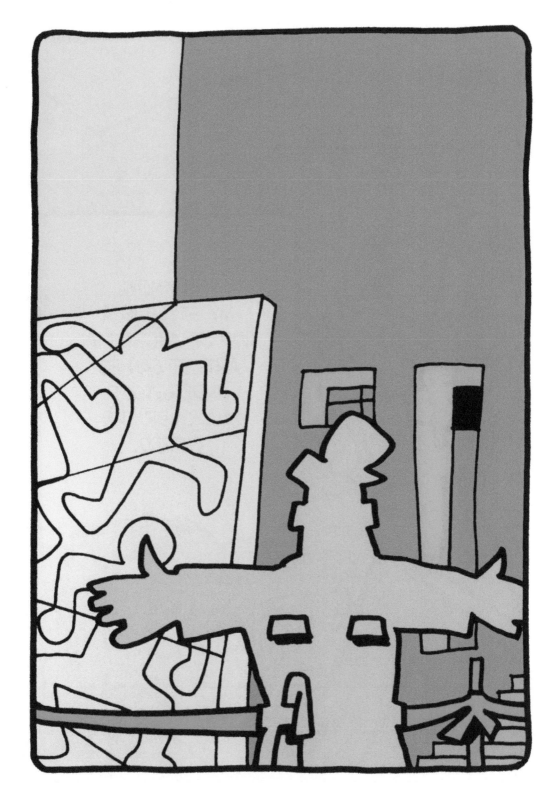

In Bordeaux, France, Keith first has to obtain a bible for his rendering of the "10 Commandments."

As is so often the case, the museum management is on the verge of a heart attack. The reason? Haring shows up 3 days before the opening without any sketches for the painting of the walls.

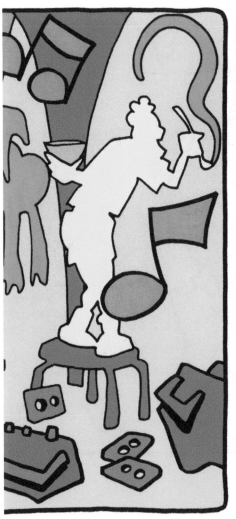

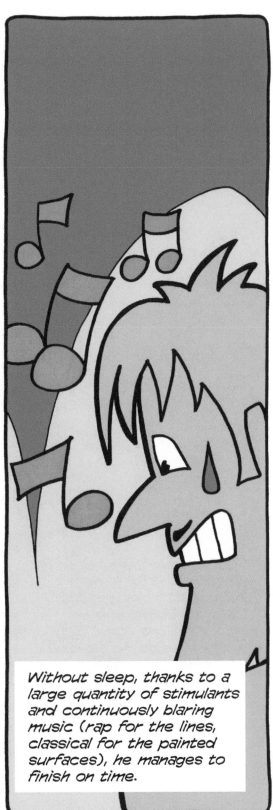

Without sleep, thanks to a large quantity of stimulants and continuously blaring music (rap for the lines, classical for the painted surfaces), he manages to finish on time.

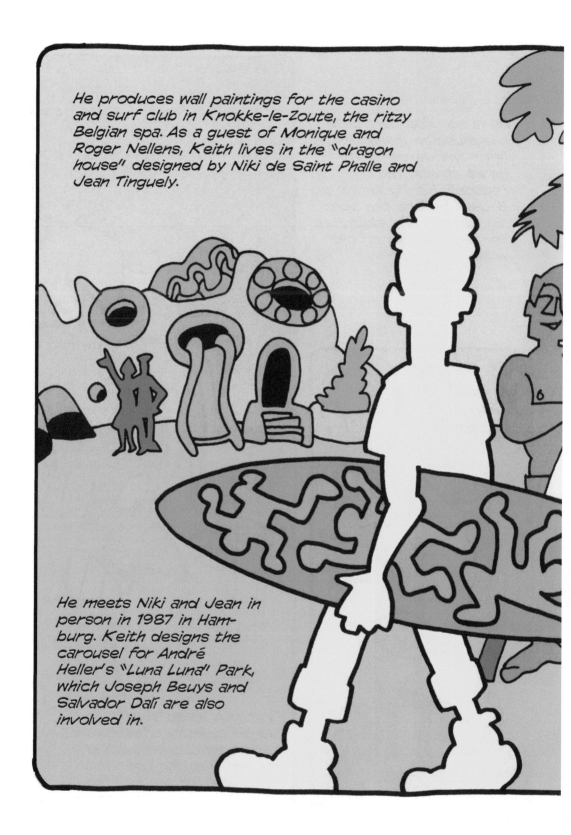

He produces wall paintings for the casino and surf club in Knokke-le-Zoute, the ritzy Belgian spa. As a guest of Monique and Roger Nellens, Keith lives in the "dragon house" designed by Niki de Saint Phalle and Jean Tinguely.

He meets Niki and Jean in person in 1987 in Hamburg. Keith designs the carousel for André Heller's "Luna Luna" Park, which Joseph Beuys and Salvador Dalí are also involved in.

He is irritated all the more by the lack of recognition from American museums.

FUCK EVERYONE IN AMERICA. I WILL DO MY STUFF IN EUROPE!

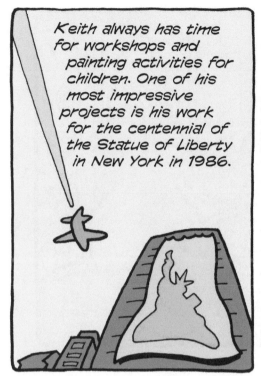

Keith always has time for workshops and painting activities for children. One of his most impressive projects is his work for the centennial of the Statue of Liberty in New York in 1986.

For three days 1,000 children work on a giant banner. Keith directs 50 kids at a time, while those waiting are entertained by bands such as "the New Kids on the Block." The banner is hung from a skyscraper where it spans ten floors.

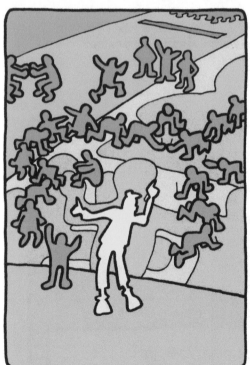

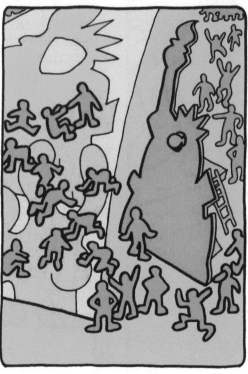

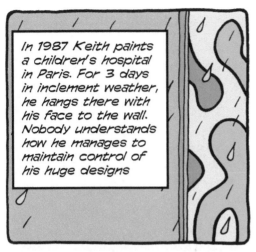

In 1987 Keith paints a children's hospital in Paris. For 3 days in inclement weather, he hangs there with his face to the wall. Nobody understands how he manages to maintain control of his huge designs

Keith always hands out buttons, t-shirts, or coloring books to children. Soon he discovers imitations everywhere. Since he doesn't feel like going to court, he opens the "Pop Shop" in New York in 1986. Bobby Breslau is the sales manager of the original Haring products. A second branch in Tokyo is not so successful and closes after a year.

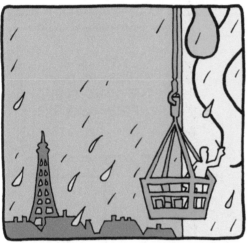

In 1986 the German gallery owner Hans Mayer arranges for giant steel sculptures designed by Haring to be produced in a foundry in Düsseldorf. Despite ever-increasing business pressures, Keith preserves his child-like zest for life.

WHY DO I HAVE TO BUY THE VINYL TARPS FROM ACME?

THAT'S WHERE BUGS BUNNY ALWAYS DOES HIS SHOPPING.

He carries off being received by Princess Caroline of Monaco, the Rothschilds, or the house of Thurn and Taxis with as much aplomb as painting the rest room area of the New York Lesbian & Gay Center.

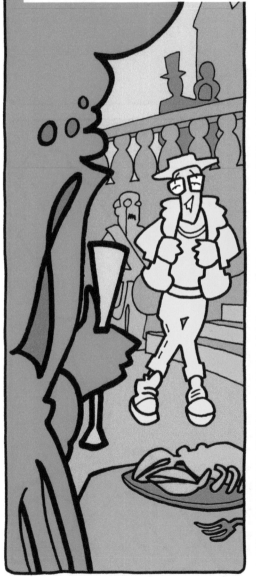

In 1988 Keith discovers some red spots on his body.

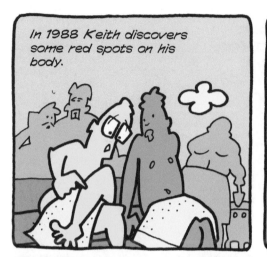

Because of his lifestyle what he had been expecting for a long time has now been confirmed: he is HIV positive. AIDS is not the only thing decimating his circle of friends. Basquiat dies from an overdose, Warhol dies following an operation. Keith flees to Madrid with 19-year-old Gil Vasquez. He is looking forward to a meeting with Yves Arman.

But Yves Arman dies in an accident on his way from Monte Carlo.

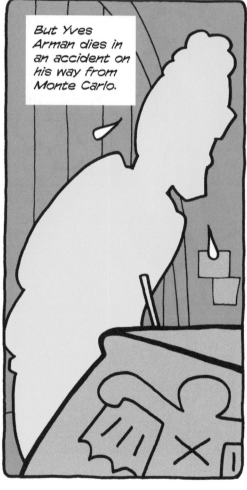

At night, while uncharacteristically listening to somewhat more muted music, Keith decorates his friend's coffin. He creates one of his last public wall paintings in Pisa, Italy. Being so near famous fresco painters moves him greatly, but it doesn't stop him from staging his appearance as an uproarious party in the streets.

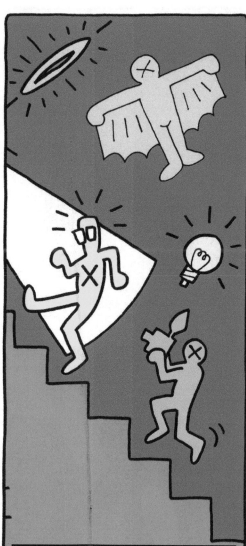

On February 16th, 1990, aged 31, Keith Haring takes his leave of the world. Three weeks later his photographer Tseng Kwong Chi follows him.

THE END

Willi Blöß — Writer & Art

Beatriz López-Caparrós — Colorist

Rolf Goellnitz — Translation

Warren Montgomery — Letterer

Darren G. Davis — Editor

Darren G. Davis
Publisher

Jason Schultz
Vice President

Jarred Weisfeld
Literary Manager

Kailey Marsh
Entertainment Manager

Maggie Jessup
Publicity

Janda Tithia
Coordinator

Warren Montgomery
Production

www.bluewaterprod.com

#ERASEHATE WITH THE MATTHEW SHEPARD FOUNDATION

With your donated dollars and volunteer hours, we work tirelessly to erase hate from every corner of America through our programs.

SPEAKING ENGAGEMENTS

Since Matt's death in 1998, Judy and Dennis have been determined to prevent others from similar tragedies. By sharing their story, they are able to carry on Matt's legacy.

HATE CRIMES REPORTING

Our work to improve reporting includes conducting trainings for law enforcement agencies, building relationships between community leaders and law enforcement, and developing policy reform in reporting practices.

LARAMIE PROJECT

MSF offers support to productions of The Laramie Project, which depicts the events leading up to and after Matt's murder. It remains one of the most performed plays in America.

MATTHEW'S PLACE

MatthewsPlace.com is a blog designed to provide young LGBTQ+ people with an outlet for their voices. From finance to health to love and dating, and everything in between, our writers contribute excellent material.

Erase Hate

Matthew Shepard Foundation
embracing diversity

Lightning Source UK Ltd.
Milton Keynes UK
UKHW050939180223
417113UK00003B/61